SAUK FOX 001

MENOMINEE 004

IROQUOIS 007

CREE 002

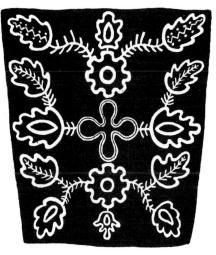

POTAWATOMI 005

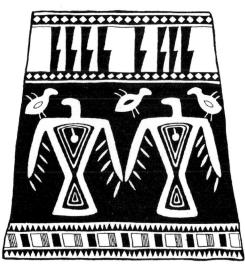

OJIBWAY 008

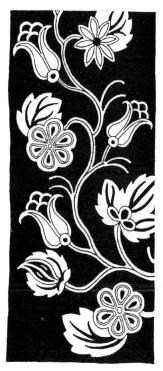

MENOMINEE 003

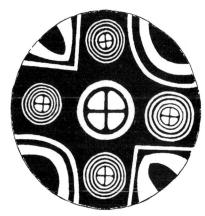

006

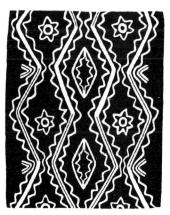

IROQUOIS 009 Eastern Woodlands

1

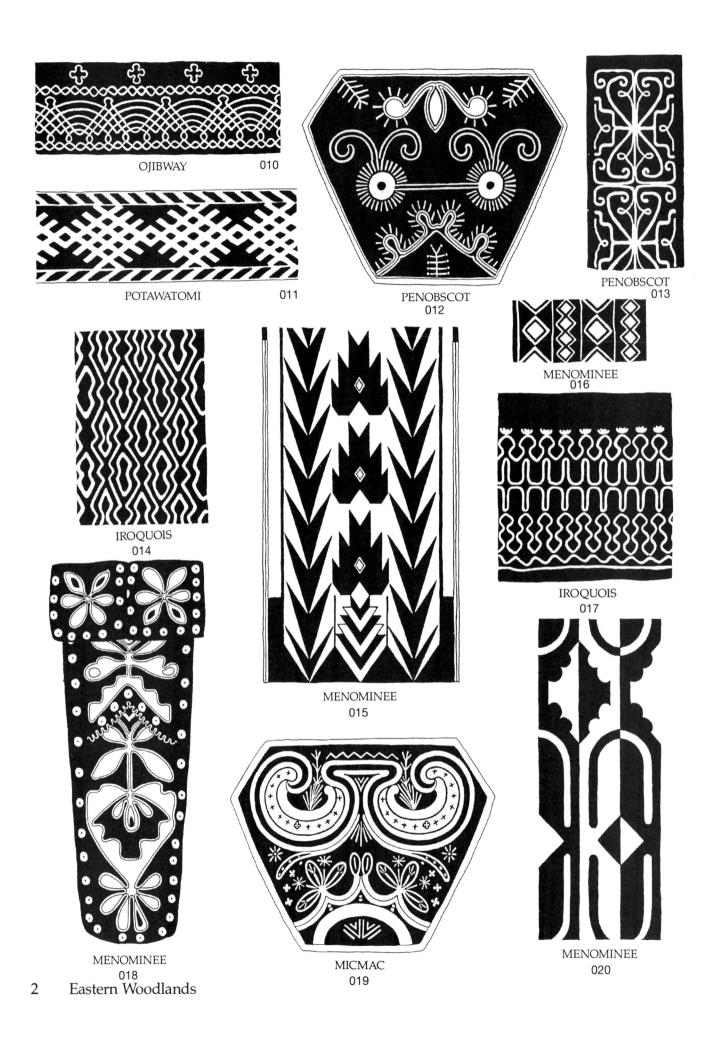

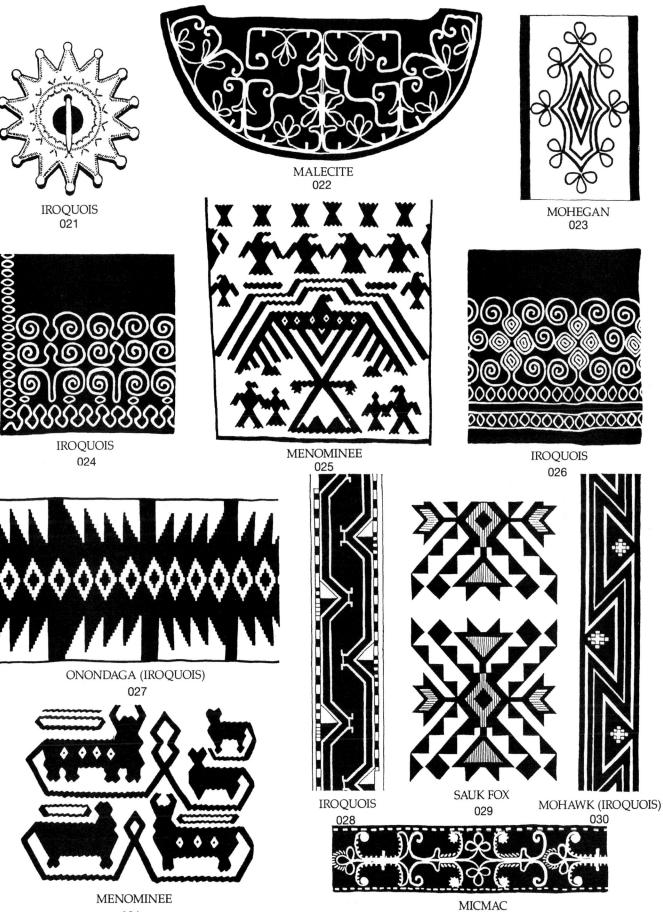

Eastern Woodlands

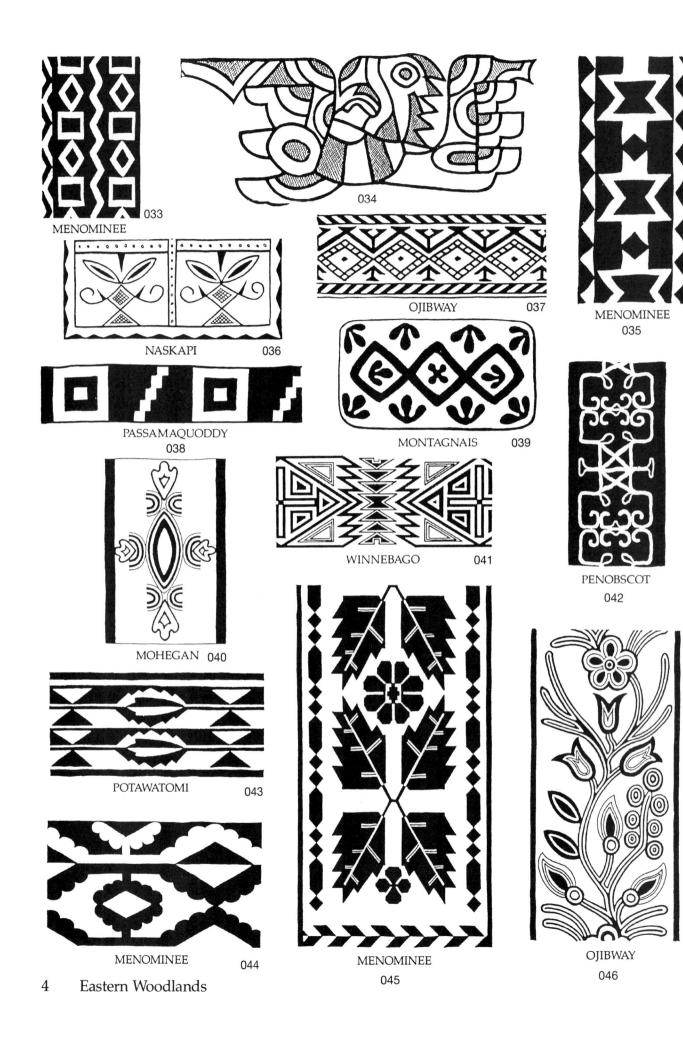

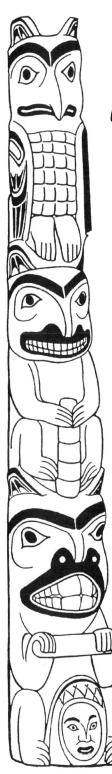

HAIDA

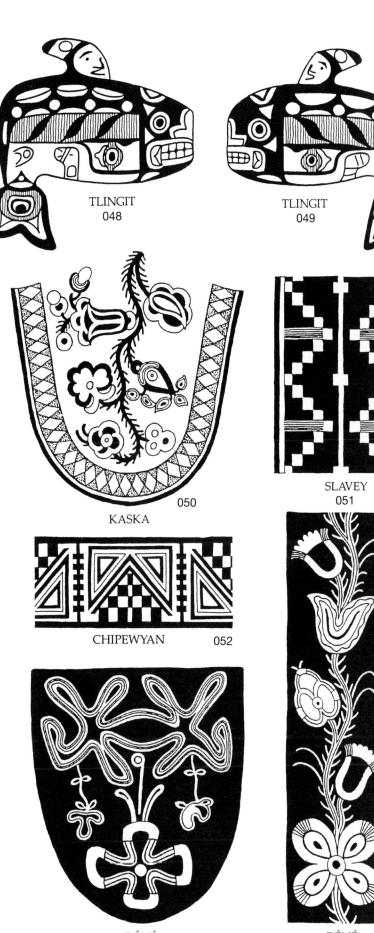

DÉNÉ

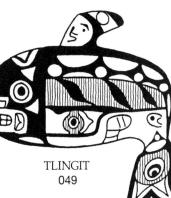

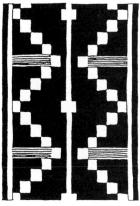

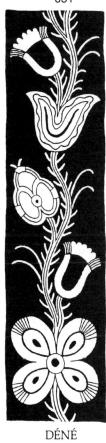

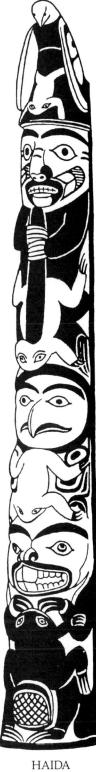

Pacific Northwest and Arctic

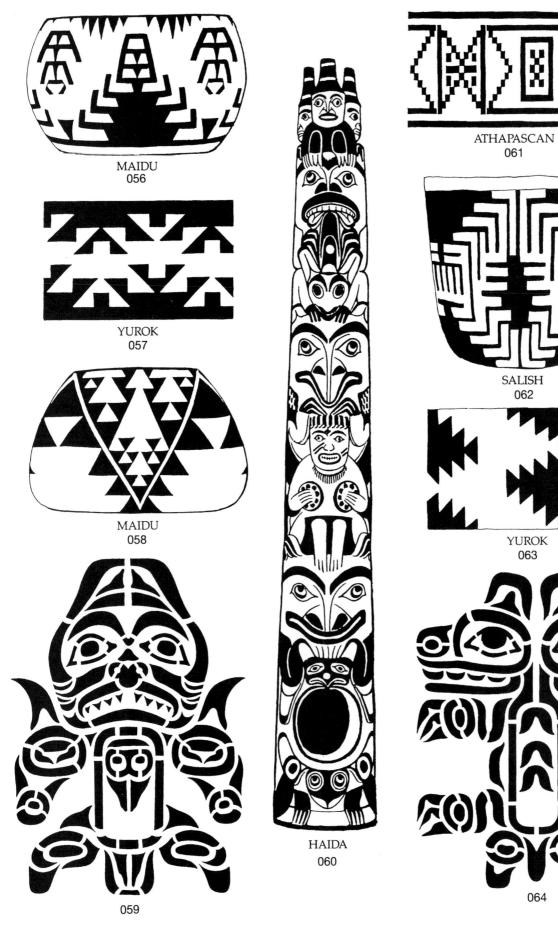

67

6 Pacific Northwest and Arctic

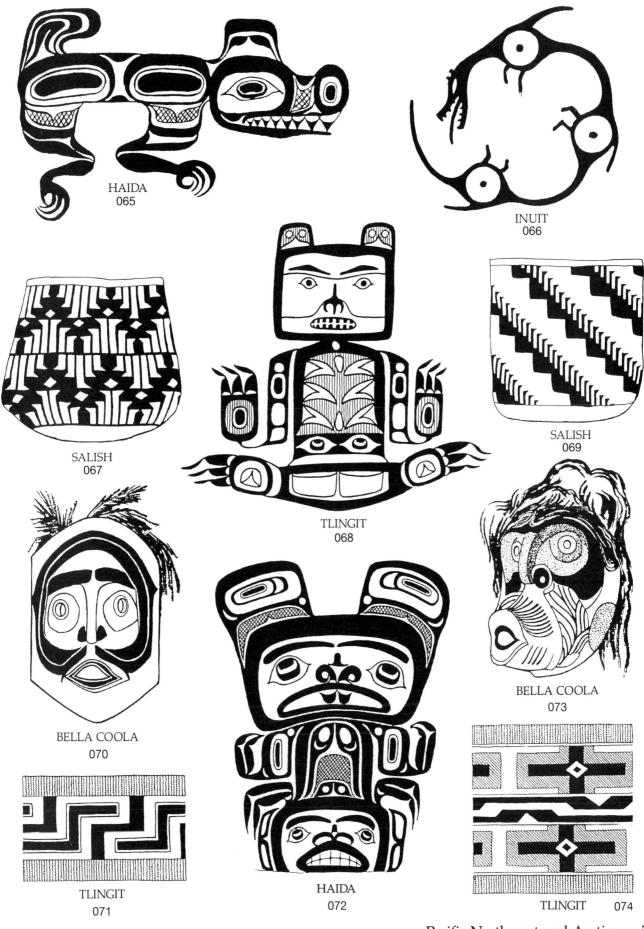

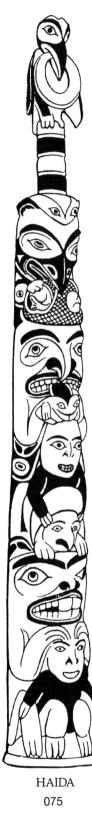

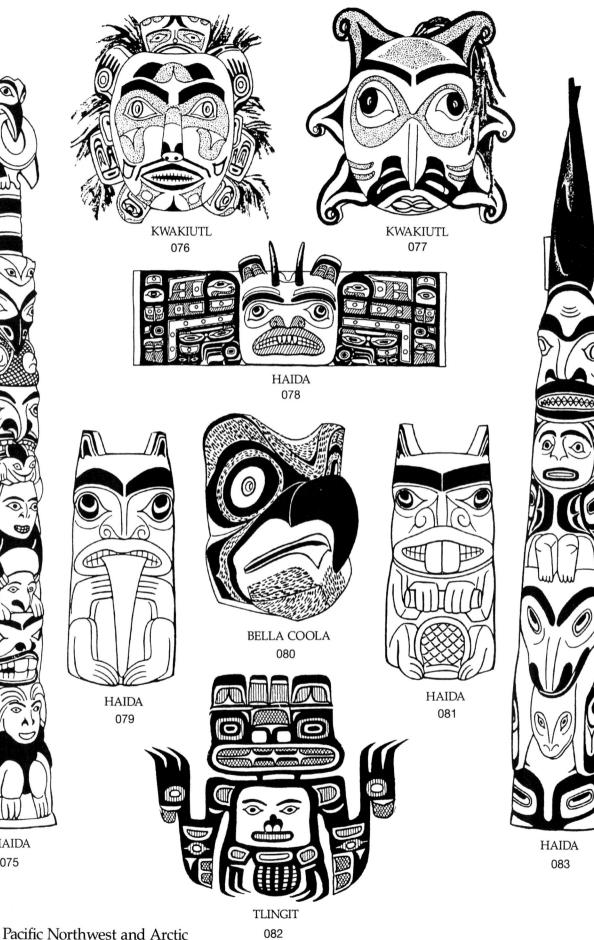

Ω

О

 \leq

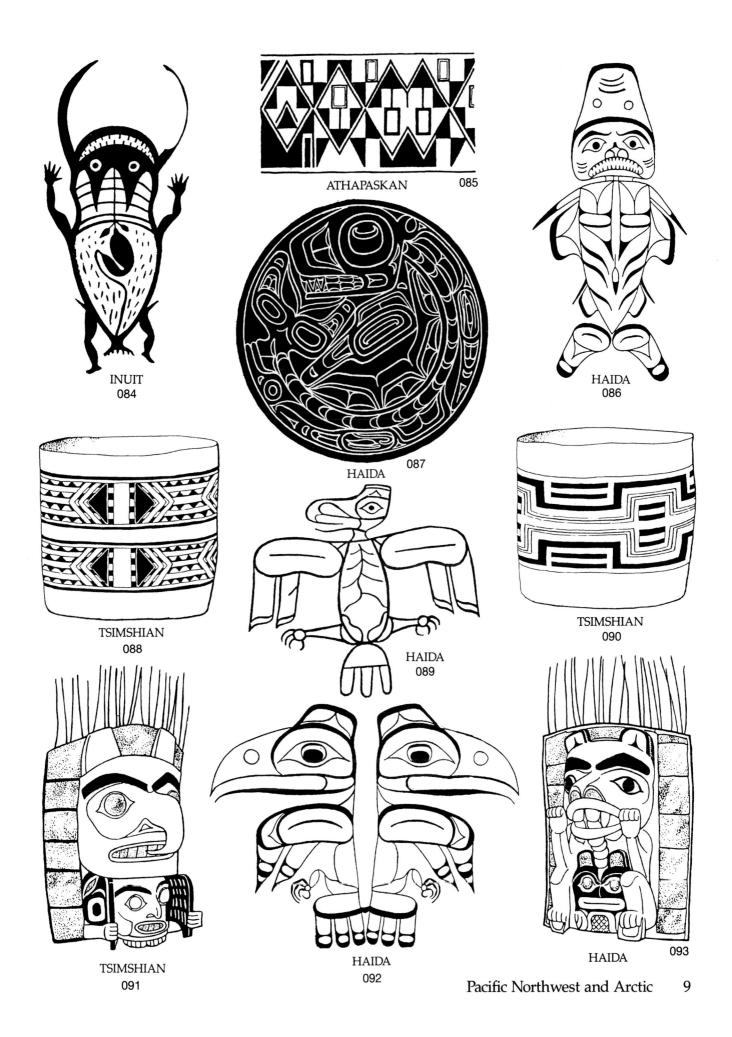

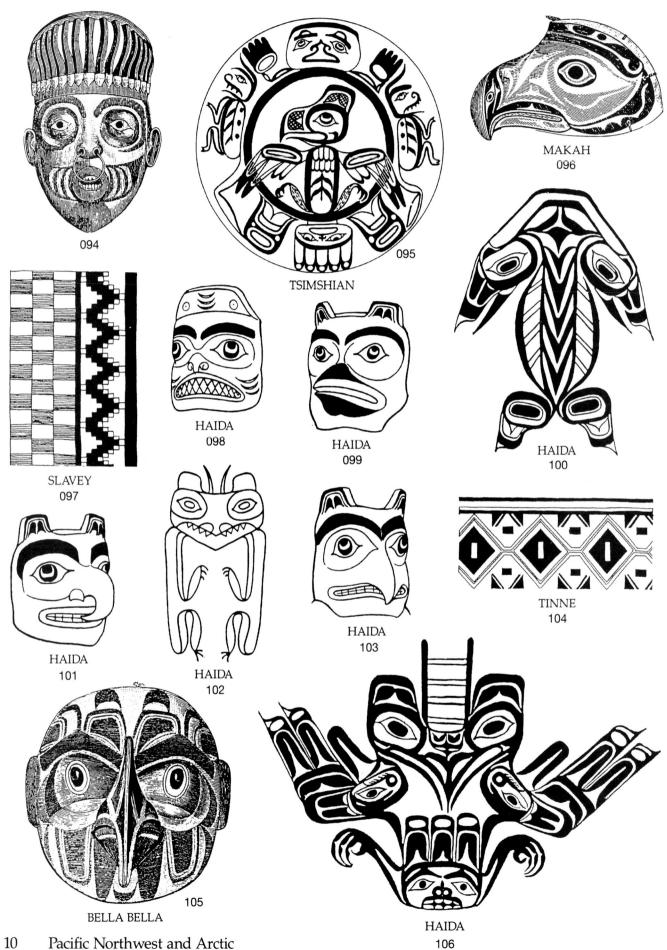

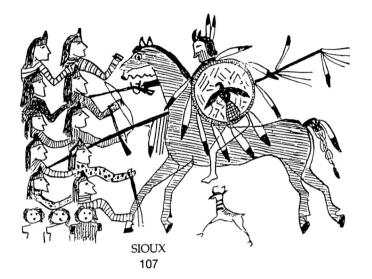

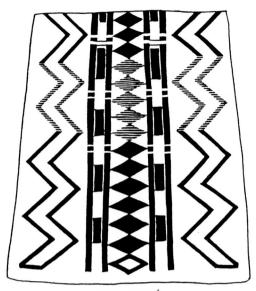

NEZ PERCÉ 108

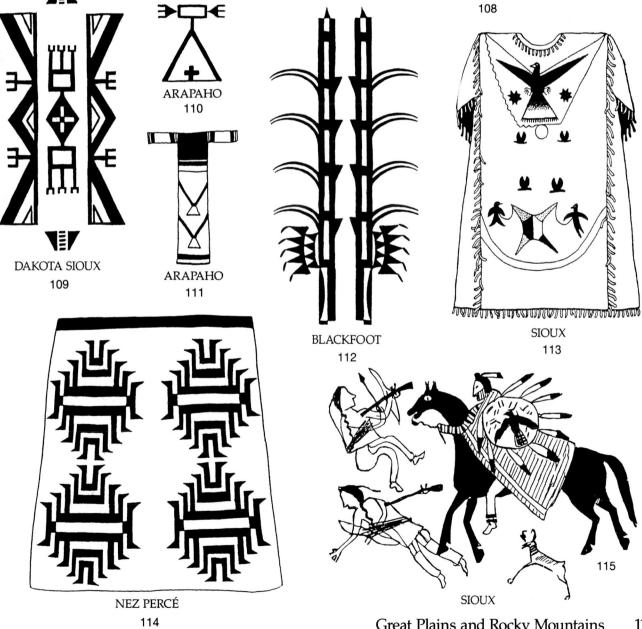

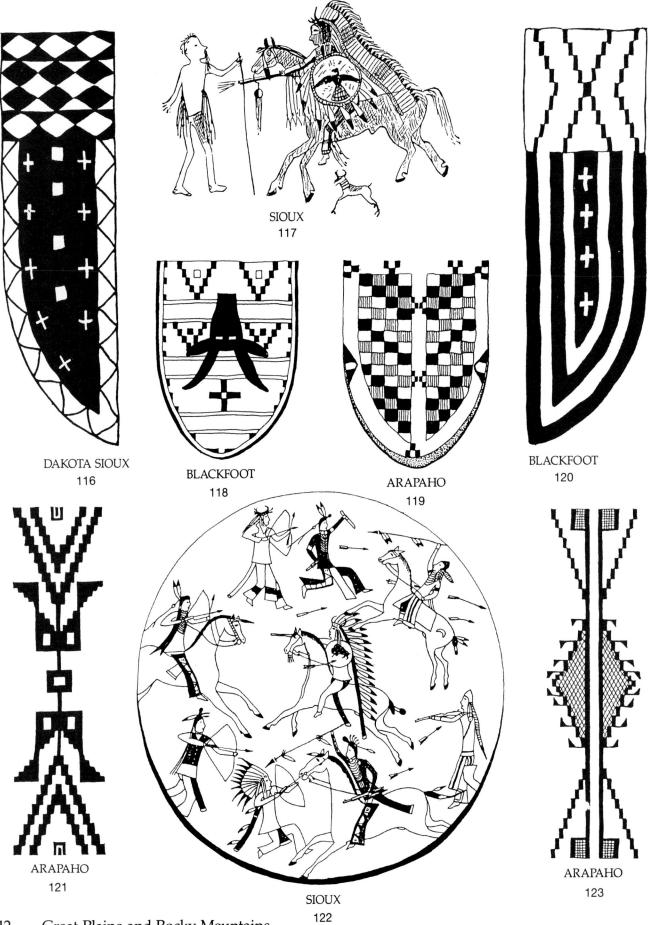

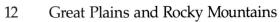

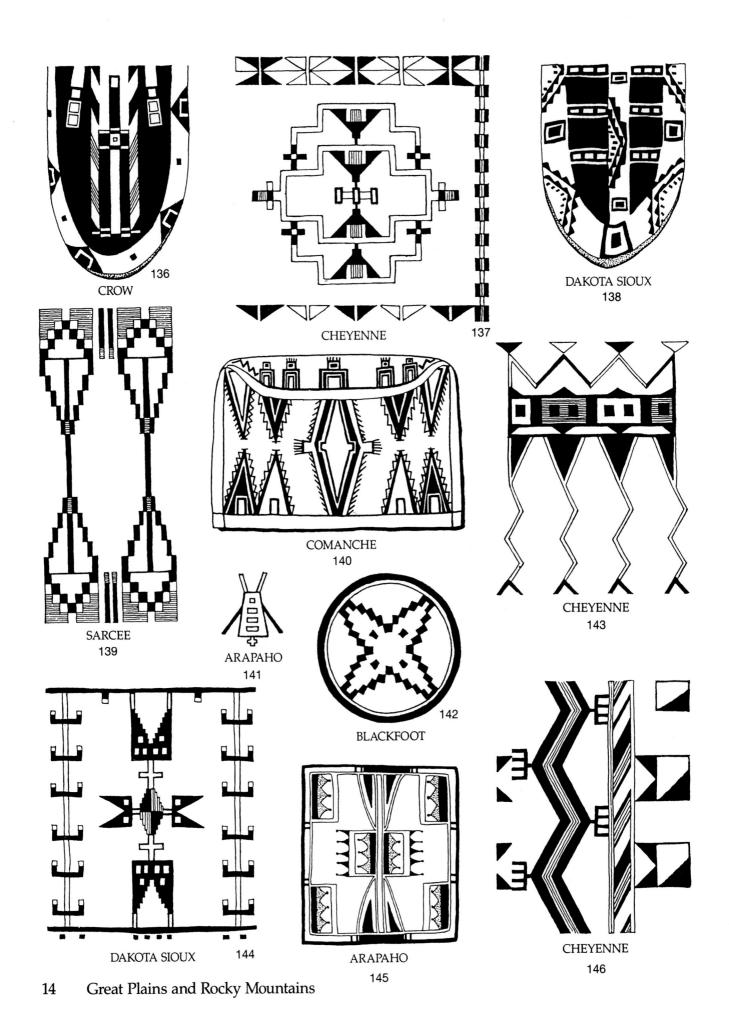

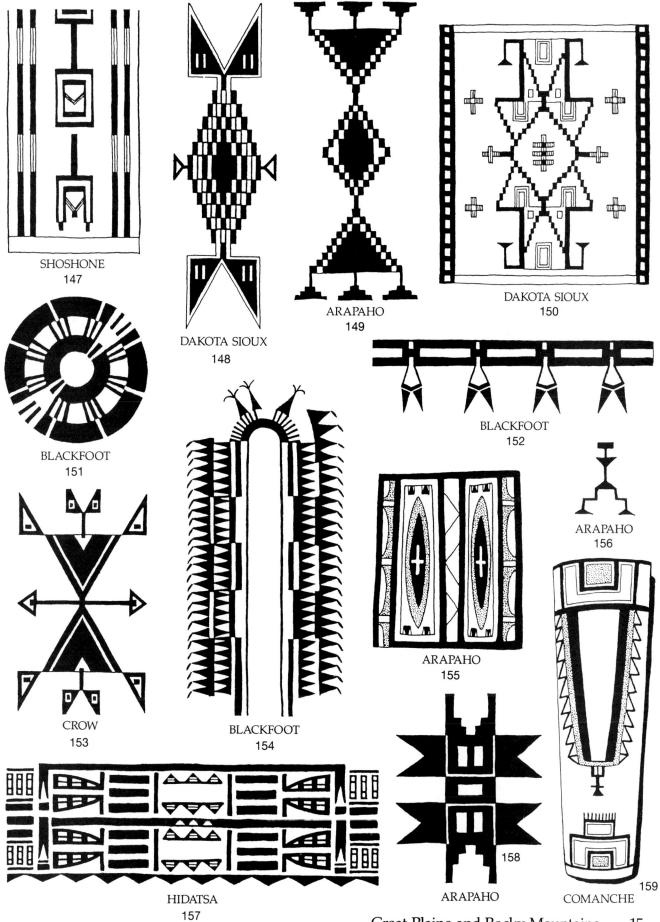

Great Plains and Rocky Mountains 15

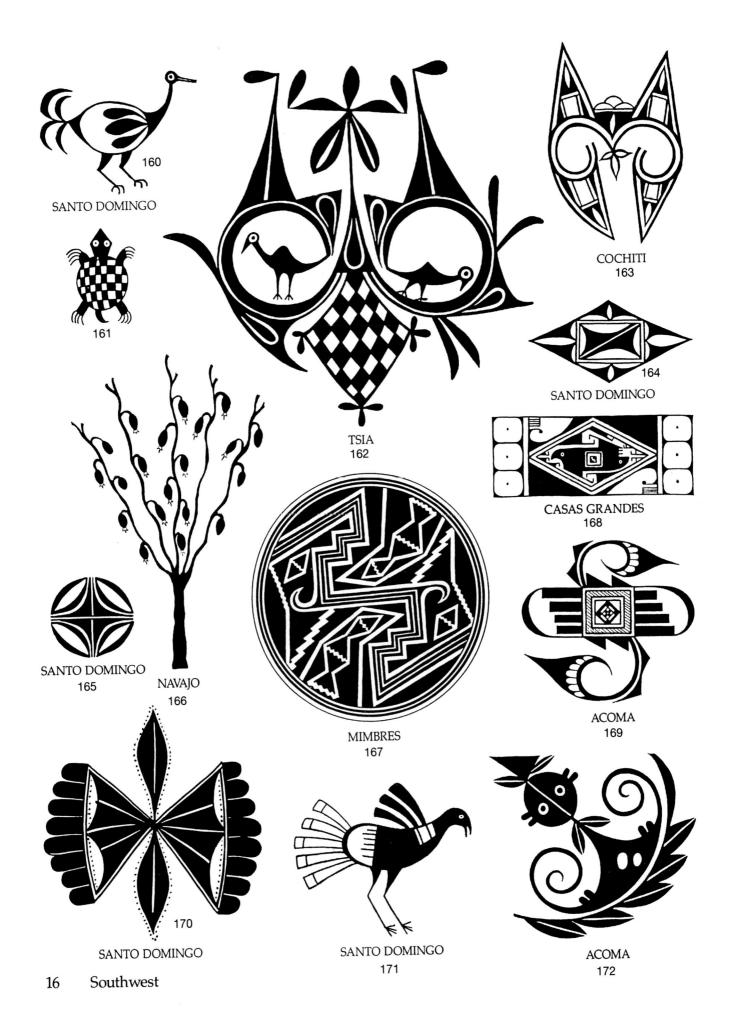

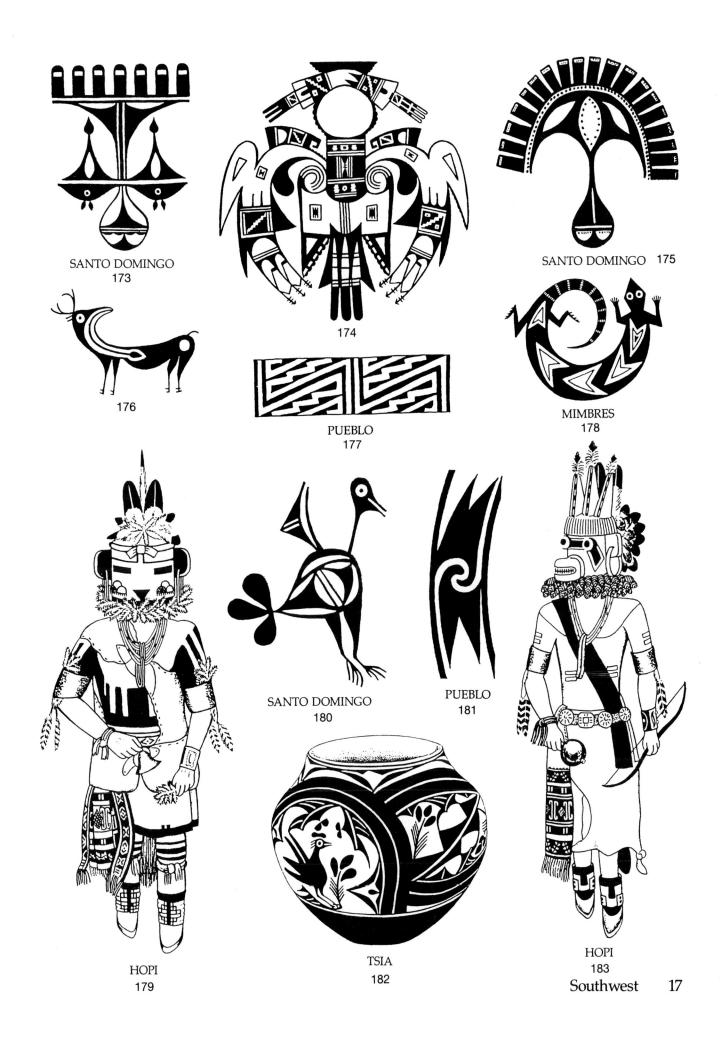

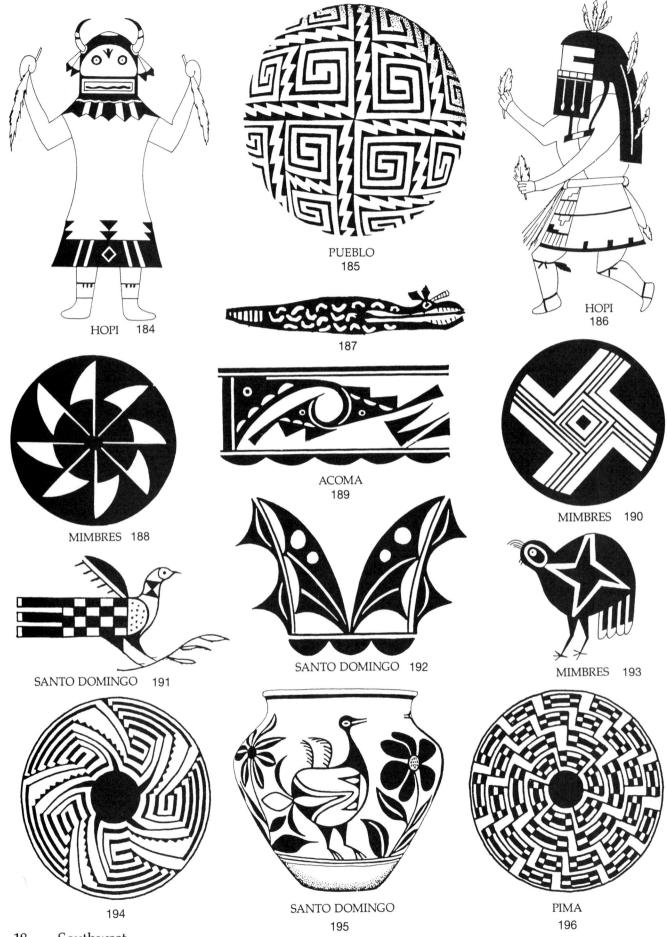

18 Southwest

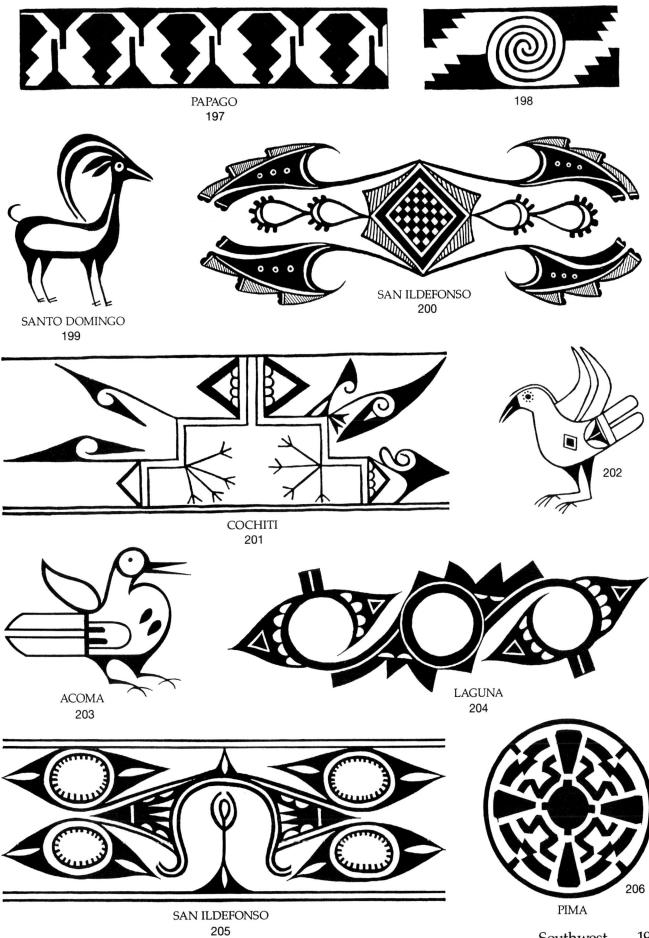

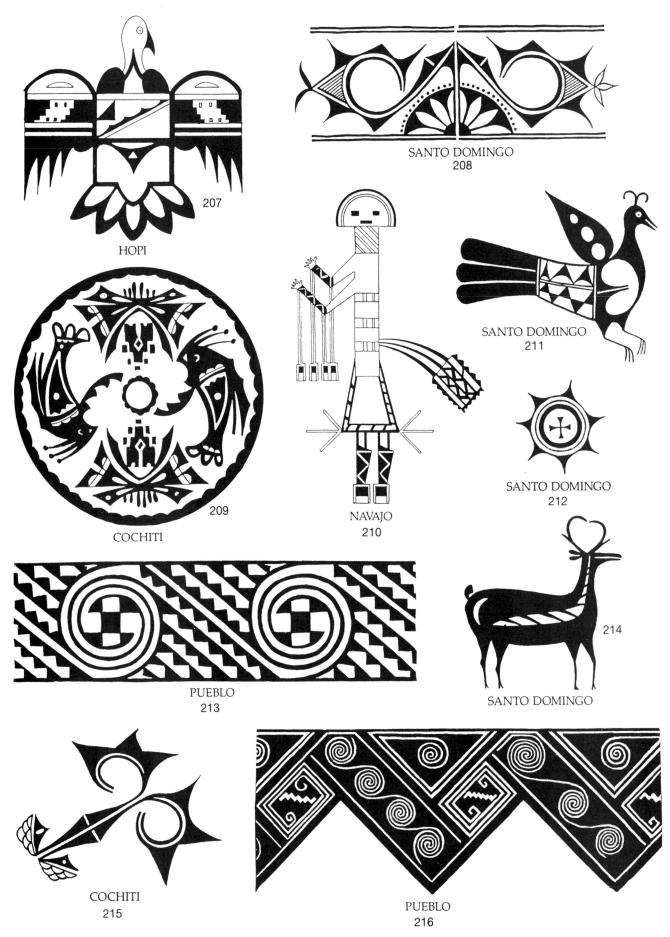

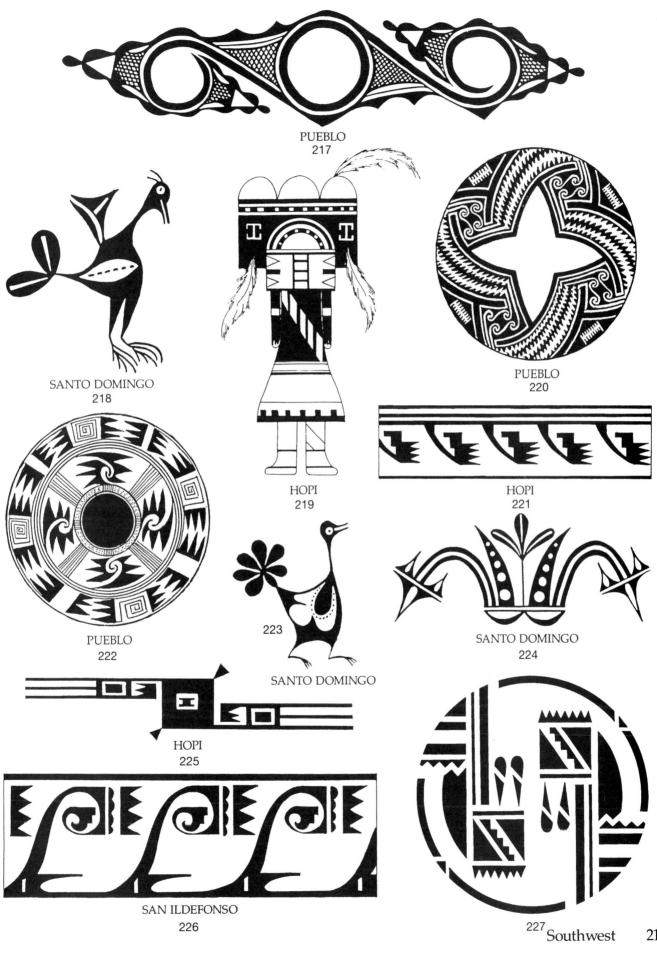

.

21

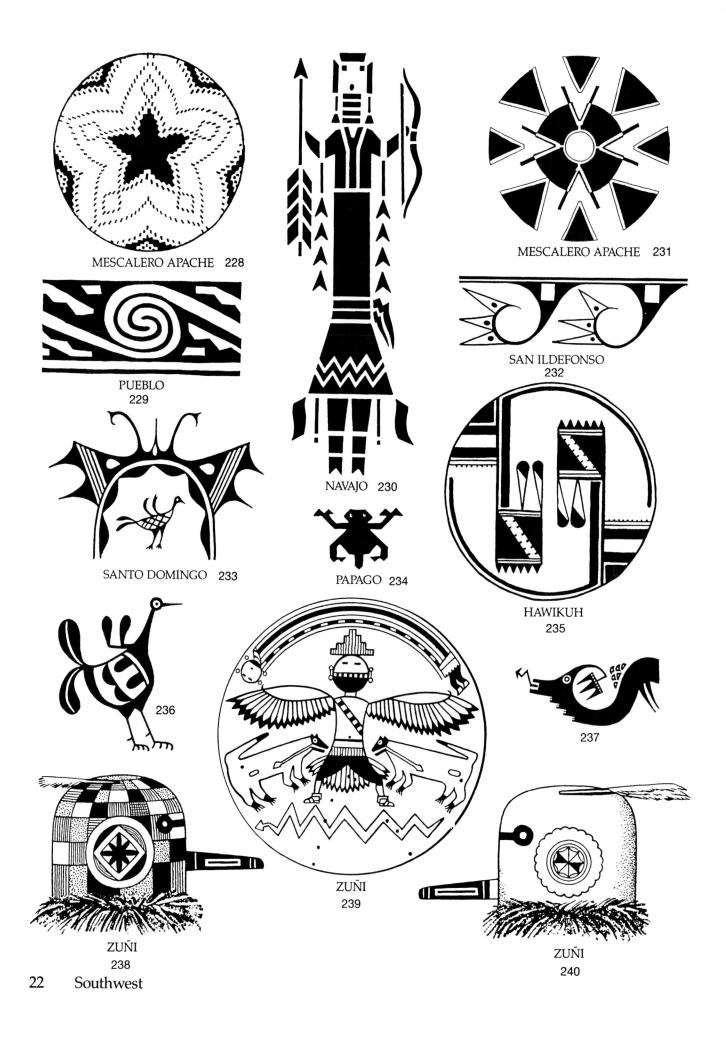

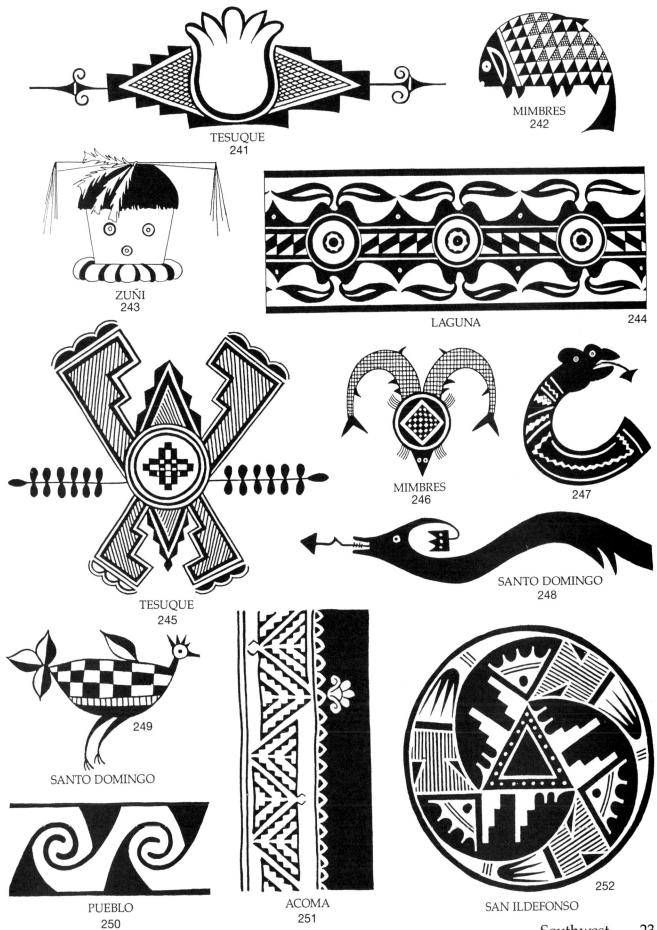

Southwest 23

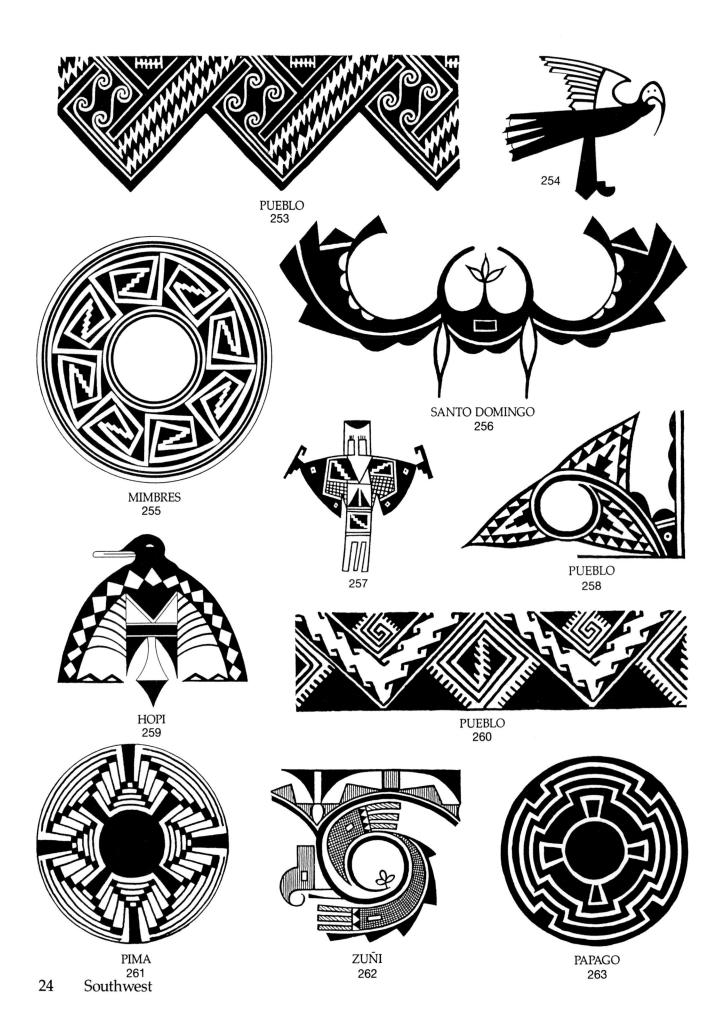

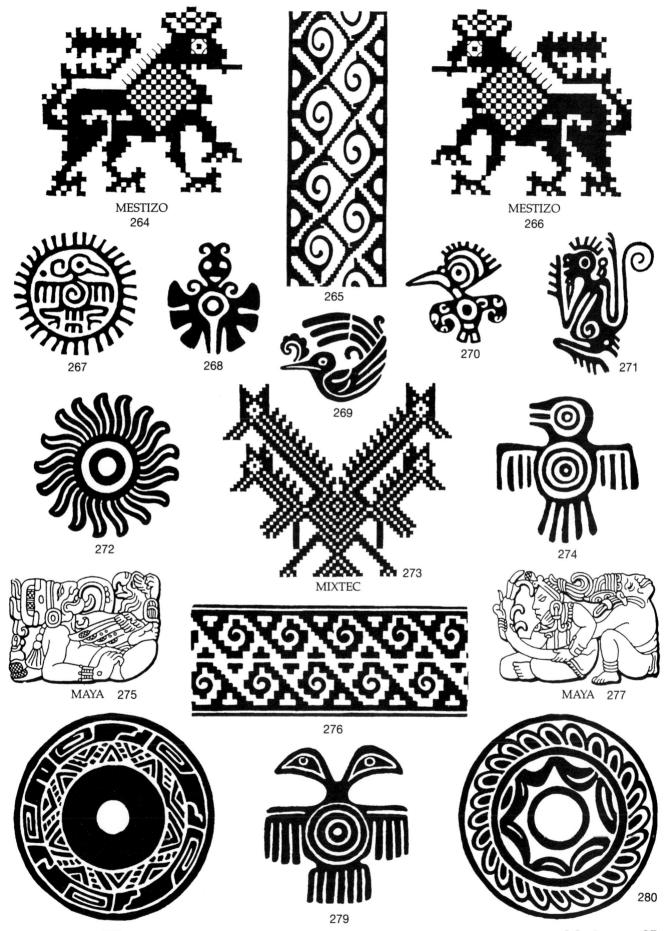

Mexico 25

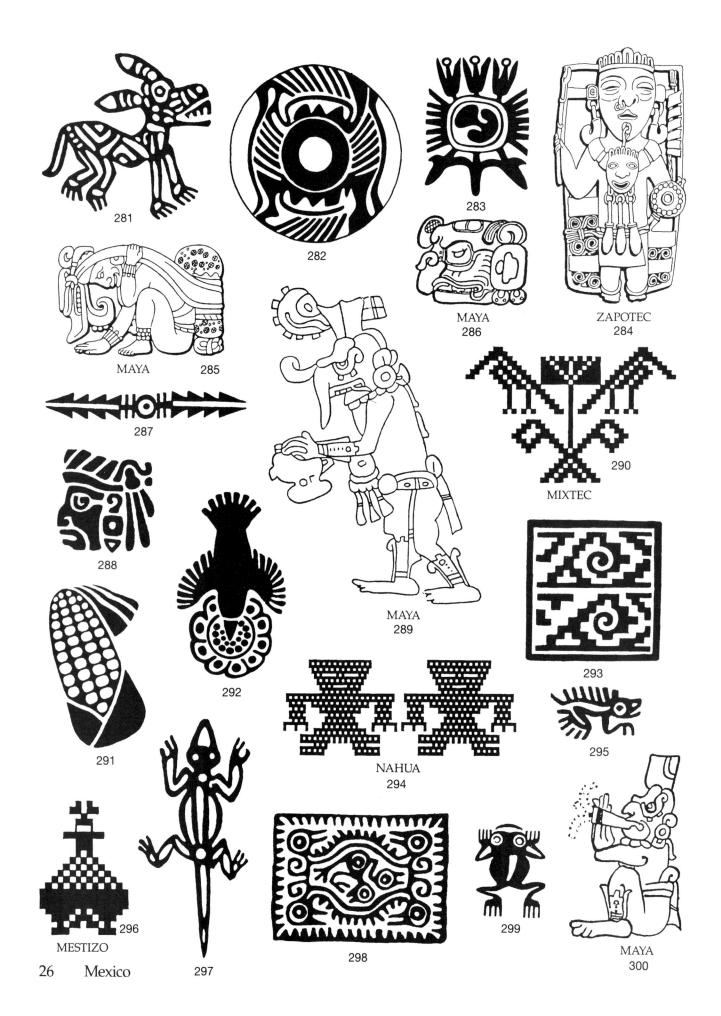

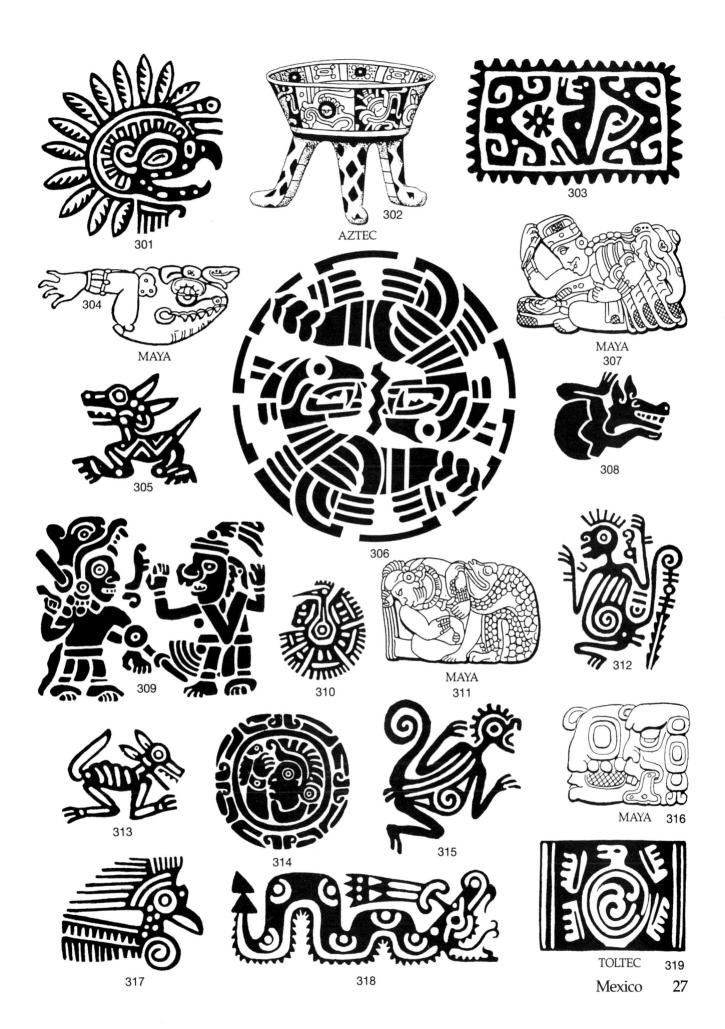

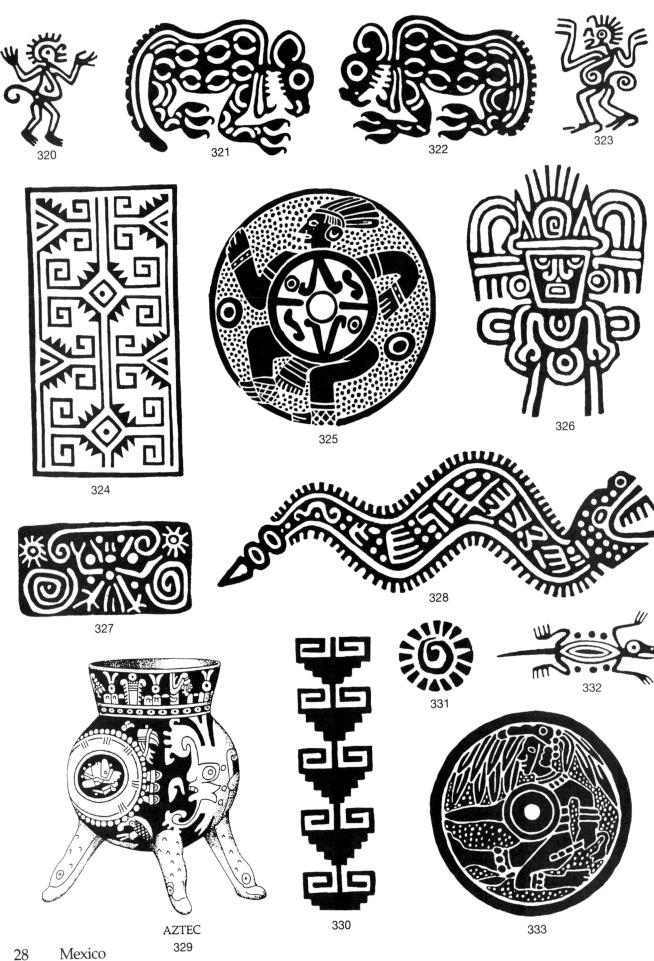

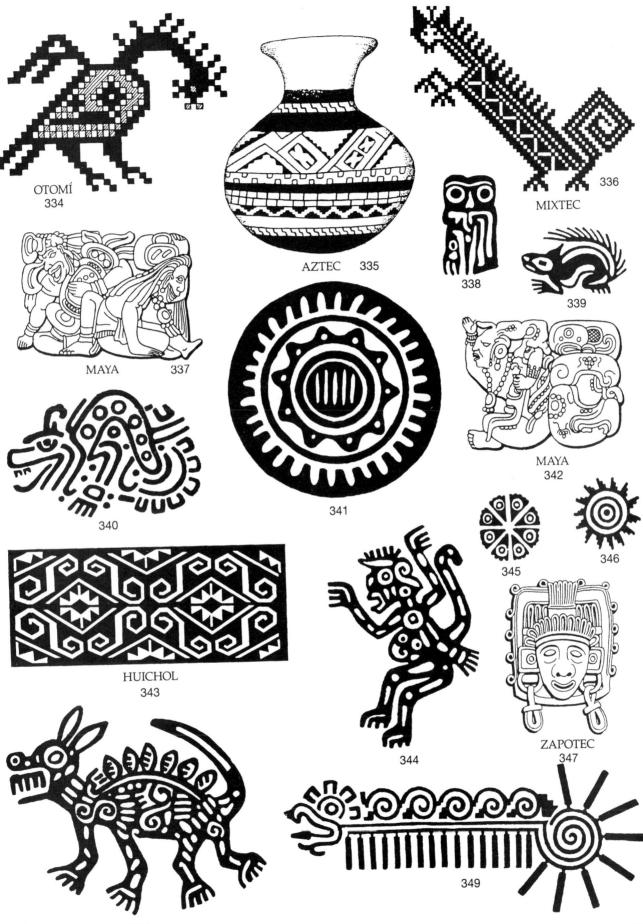

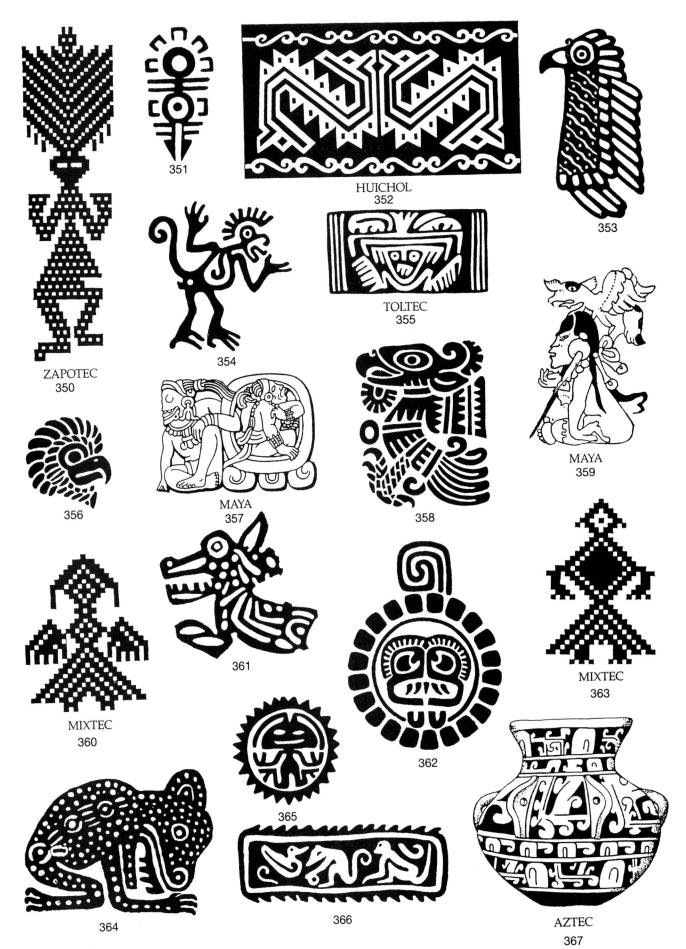

Mexico 30

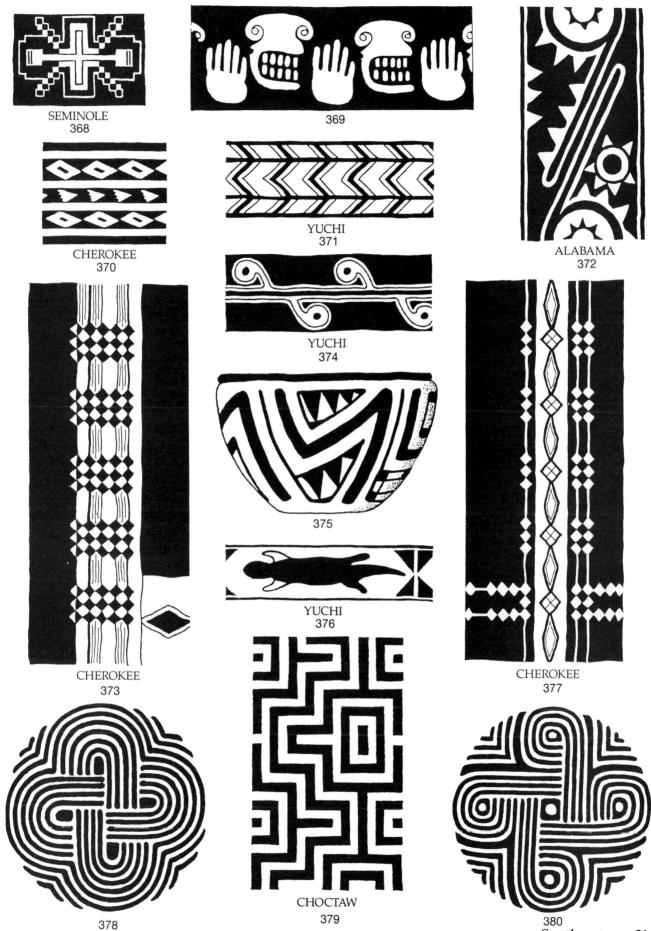

31

Southeast

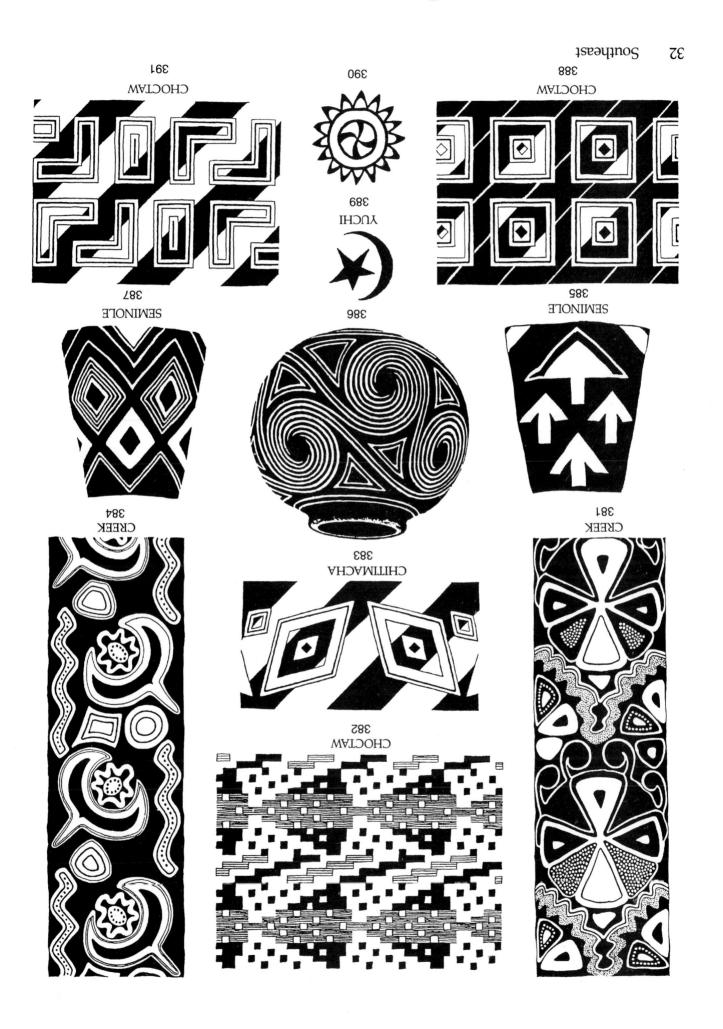